COPYCAT

COPYCAT
and a litter of other cats

a very important book by **David Yow**

AKASHIC BOOKS

Published by Akashic Books
©2014 by David Yow

ISBN-13: 978-1-61775-270-4
Library of Congress Control Number: 2013956775

Printed in China
First printing

Akashic Books
PO Box 1456
New York, NY 10009
info@akashicbooks.com
www.akashicbooks.com

for Little Buddy, Penny, and Nico

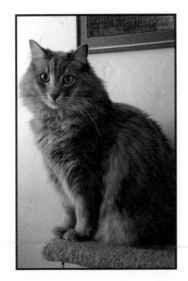 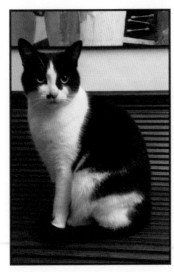 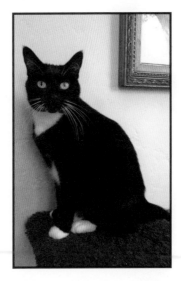

and Me Yow, Spunky, Miss M, Boo,
Honey, Precious, Hugh, Space
Monkey, David, Algernon, Grady,
and Rizz Rizz Rizz

Thank you:
Ellen Philips
Derek Larson
Rob Rowe and Rhonda Reynolds
Julia Rose Brown
Josh Siegel
Bruce A. Hornstein, OD

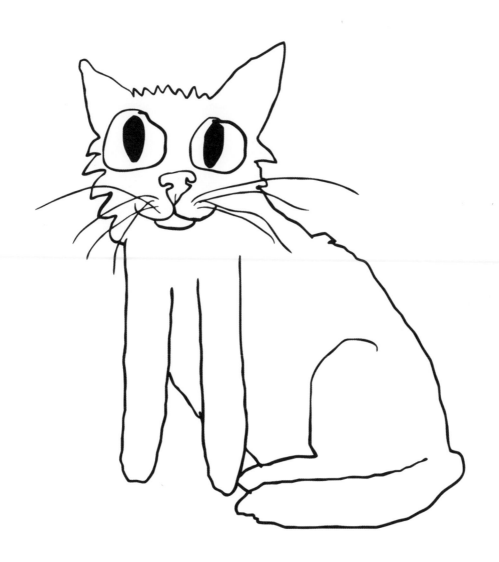

A very long time ago in Austin, Texas, I became friends with a fella goes by the name of Tom (that's Mr. van den Bout to you). He and I had a lovely time. On one particularly sunny afternoon I had my doodle pad out and I was doodlin'. I depicted something of a cartoon cat standing there just lookin' straight at ya. I put a little T-shirt on the pussycat and scribbled the name *Tom* on the front of the shirt. Makes perfect sense that I would entitle this artwork *Tomcat.* Tom was courting a delightful young lady who was known as Cheryl (that's Miss Bostick to you). I designed a very similar feline to what I had done with *Tomcat*, but made it slightly different by scrawling the name *Cheryl* on the front of the animal's garment. I gave that drawing the name *Cheryl Cat.* This foolishness led me to draw a whole litter of cats, most of which have a comical twist or a punlike idea accompanying them. The inventory grew to a number in excess of ninety. The only criterion for each cartoon was that its title contain the letters C, A, and T, in that order. I trust you to be a clever and enterprising individual, elsewise you would not be regarding this book. So please feel free to pat yourself on the back when you think up titles that I have not included herein.

David Yow

(*Cheryl Cat* did not make the grade.)

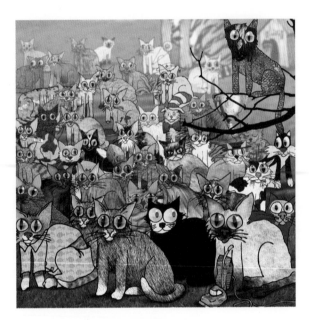

In no particular order . . .

Catatonic

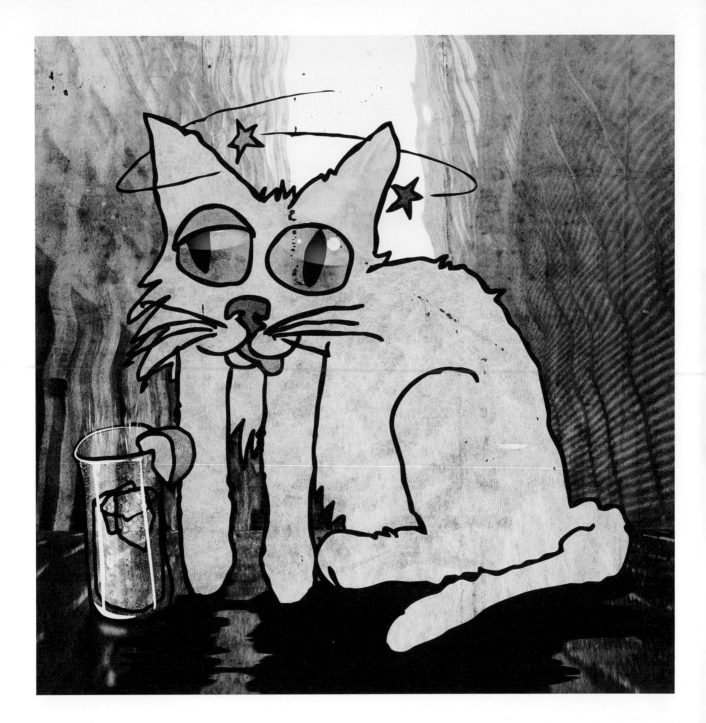

13

Alley Cat

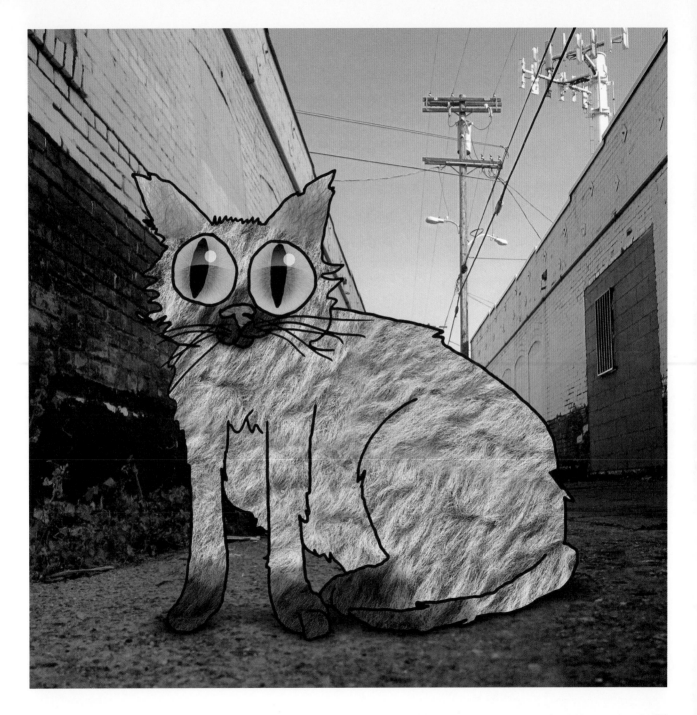

Bobcat

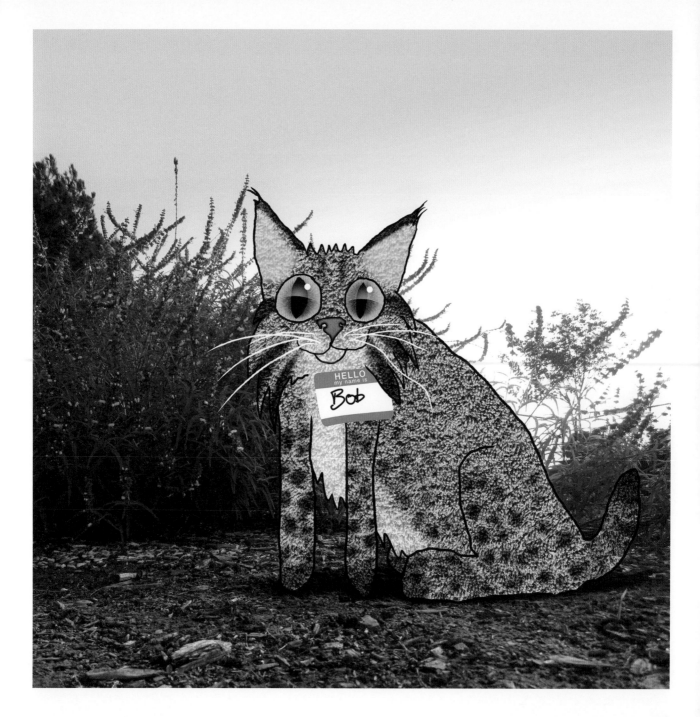

17

Catheter

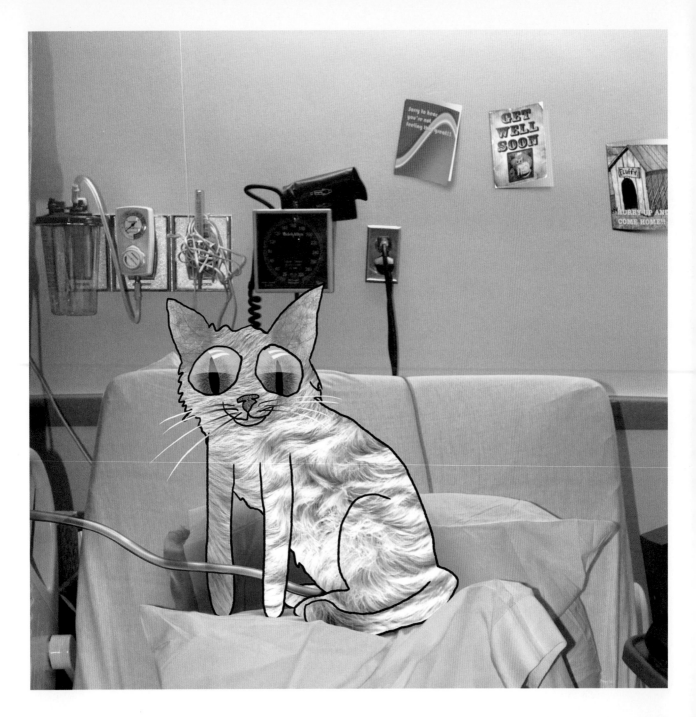

Catholic

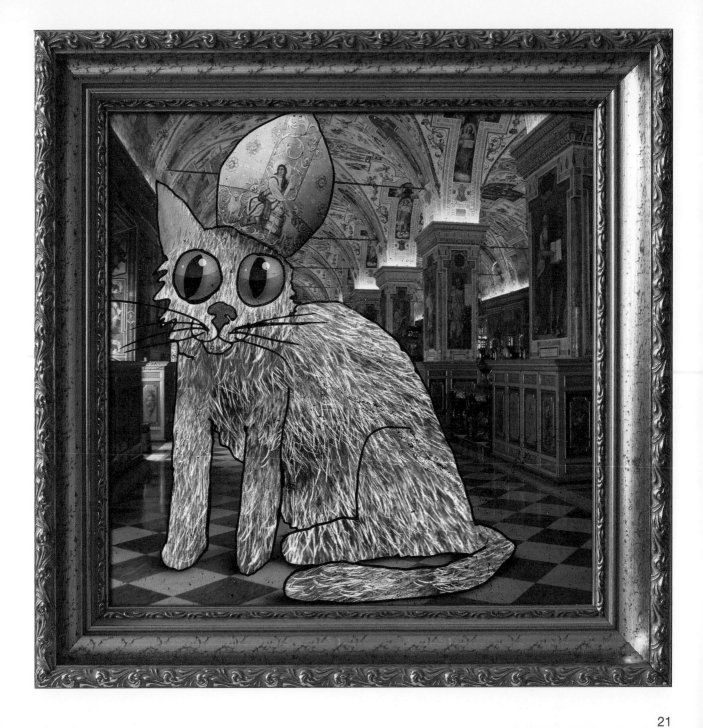

Domestic Cat

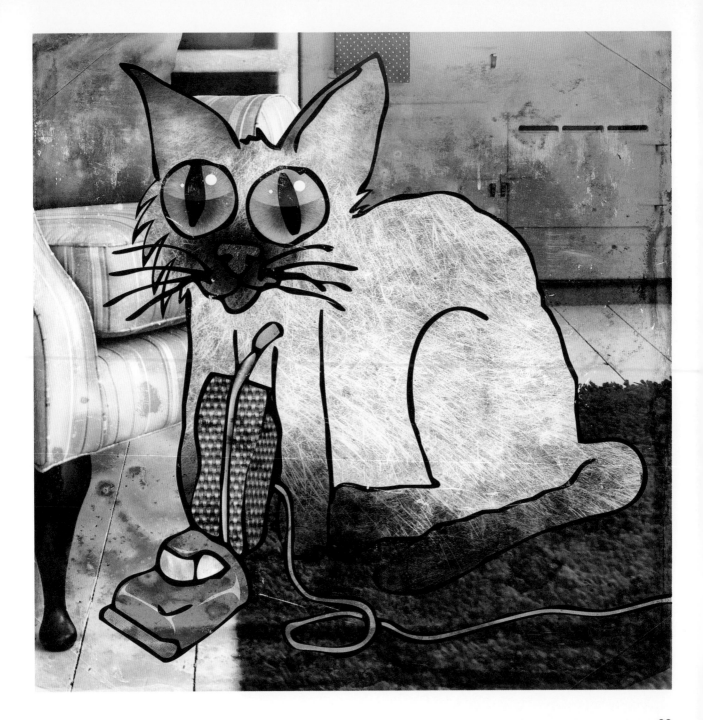

Cat on a Hot Tin Roof

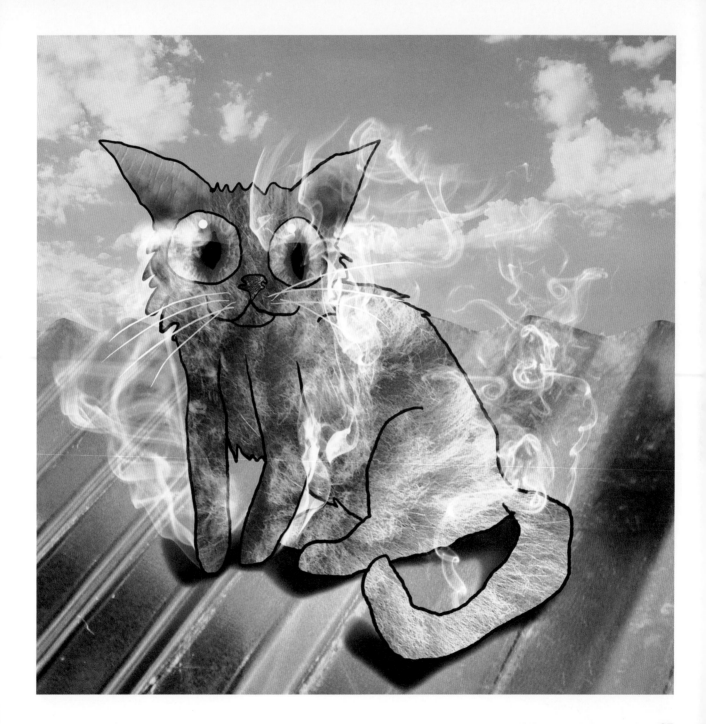

Catcall

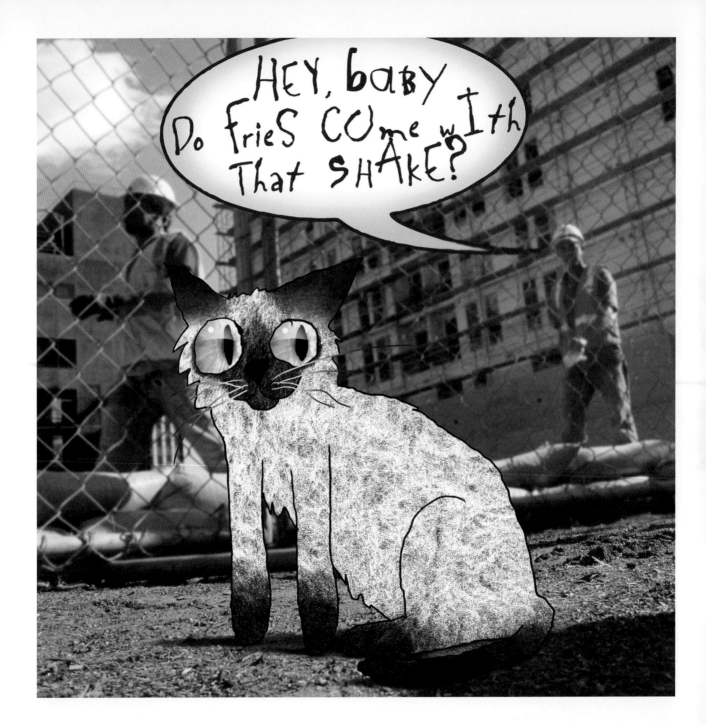

Catsup

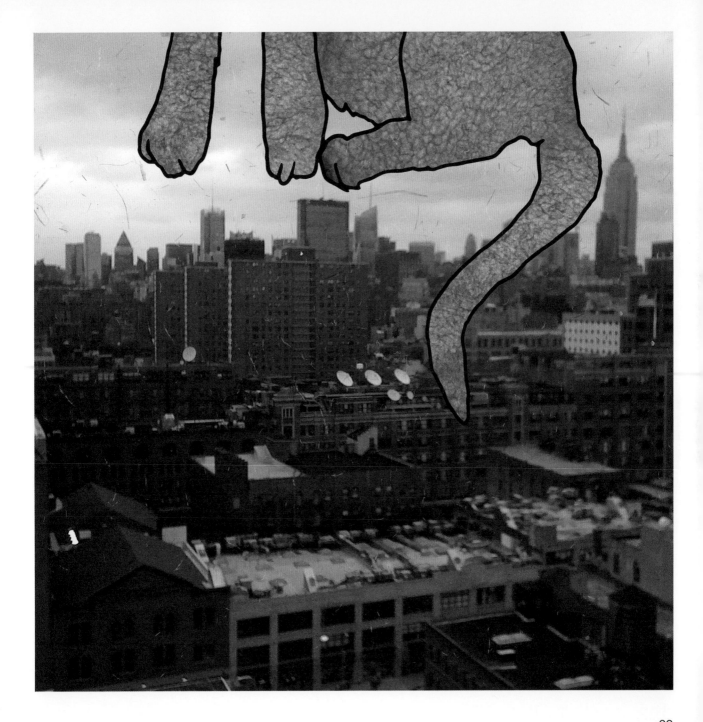

Cattails

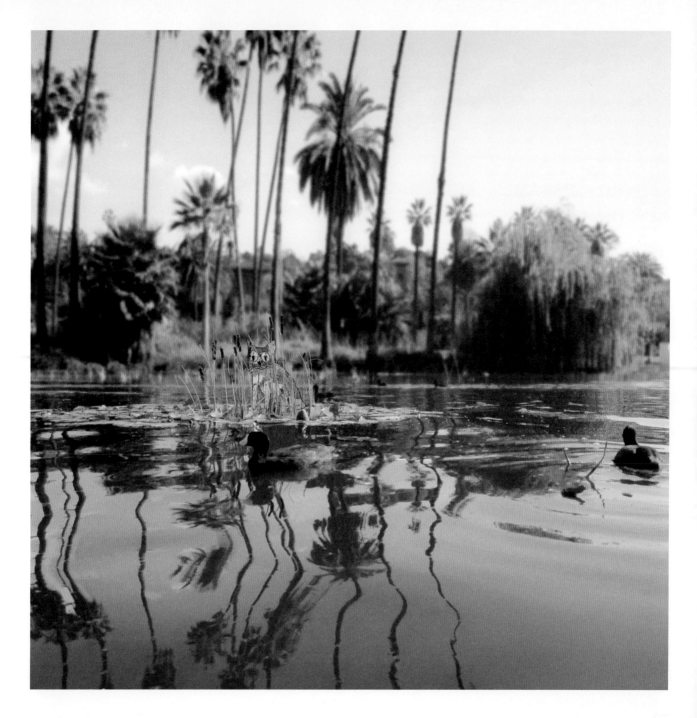

Catalina

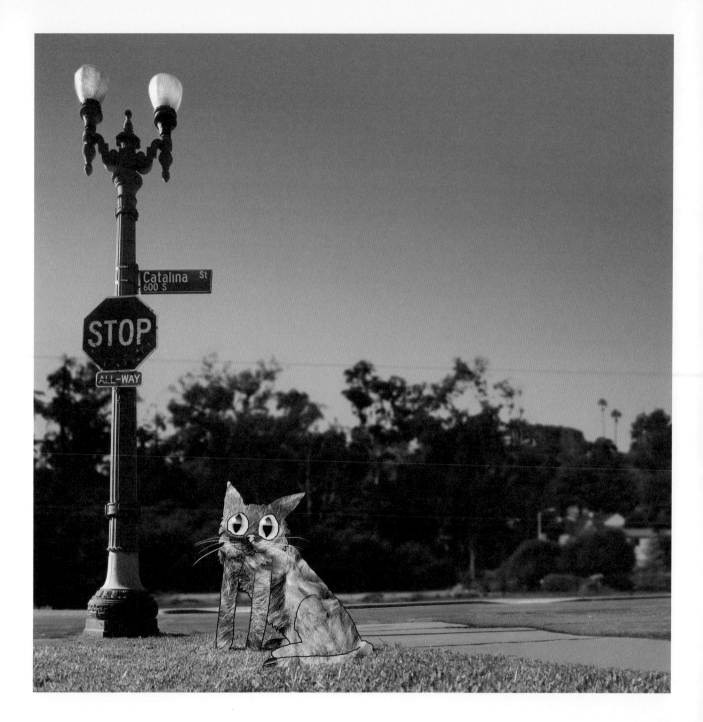

Catastrophe

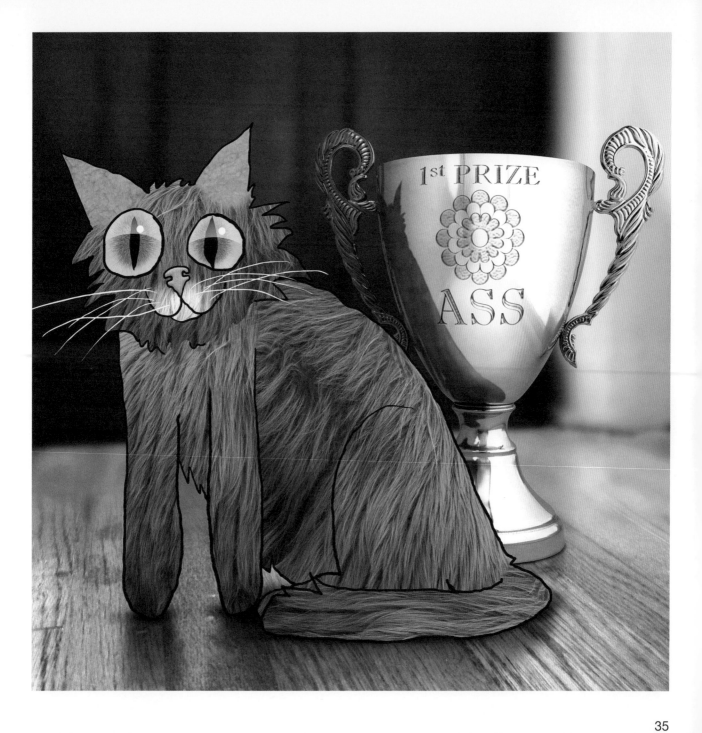

Polecat

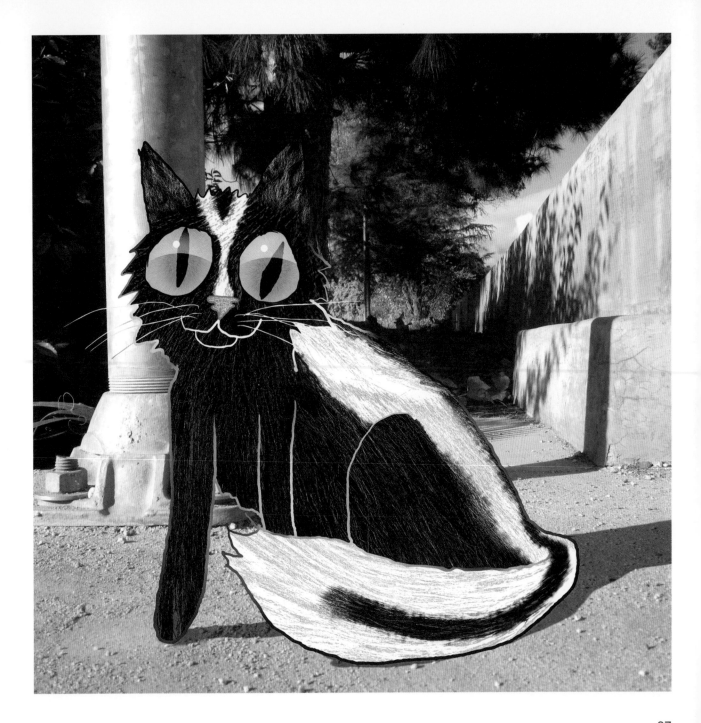

Grumpy Cat

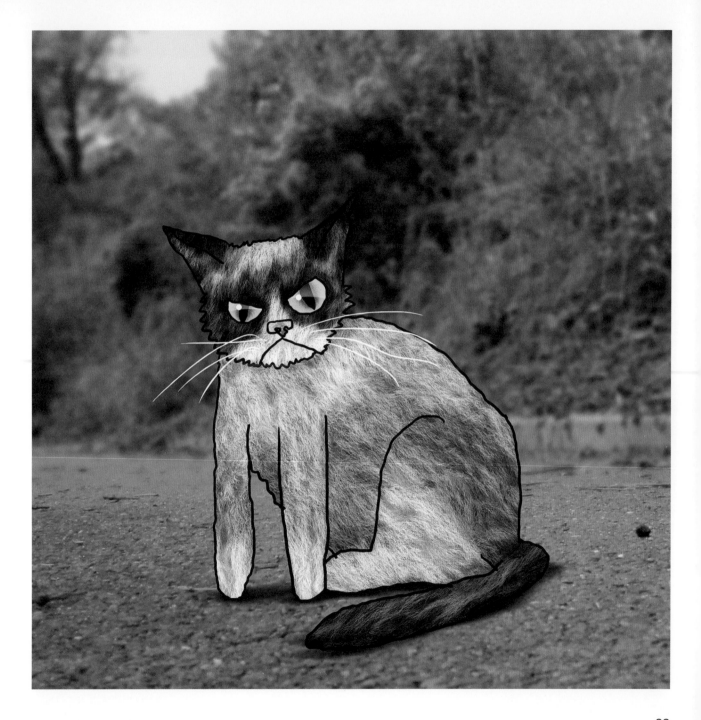

Felix the Cat

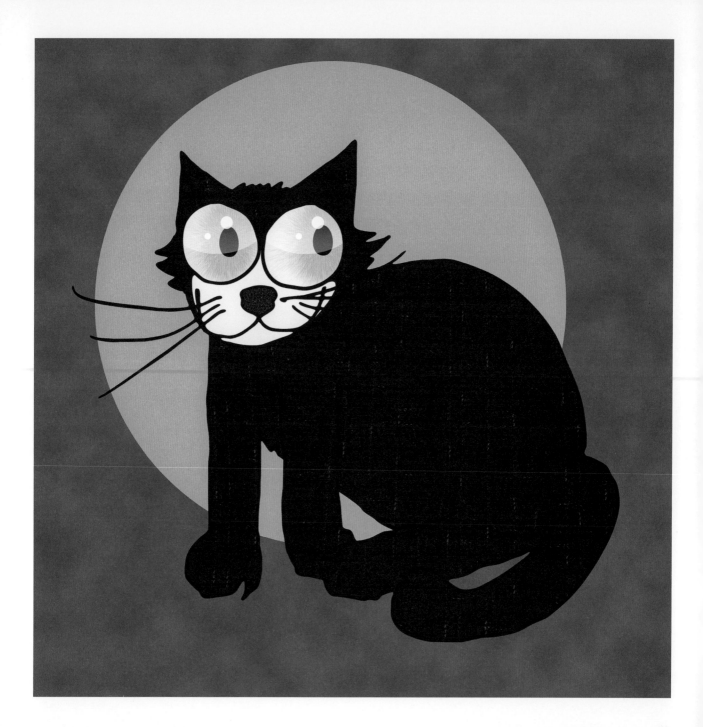

Cat Carrier

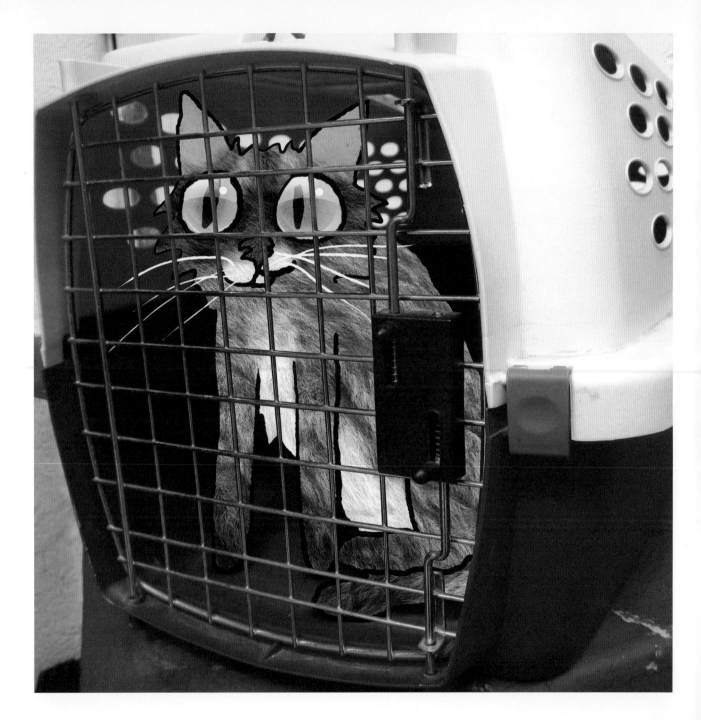

Cat Ballou

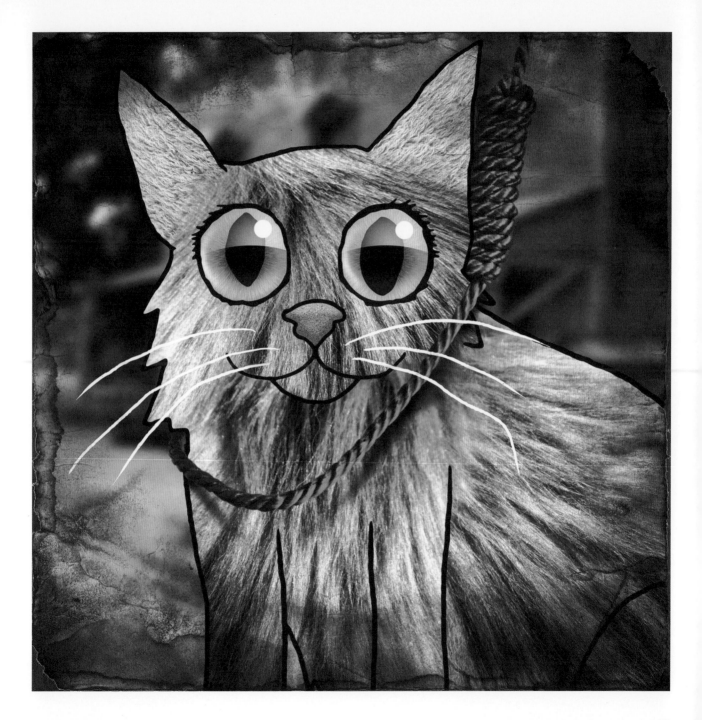

Catbird

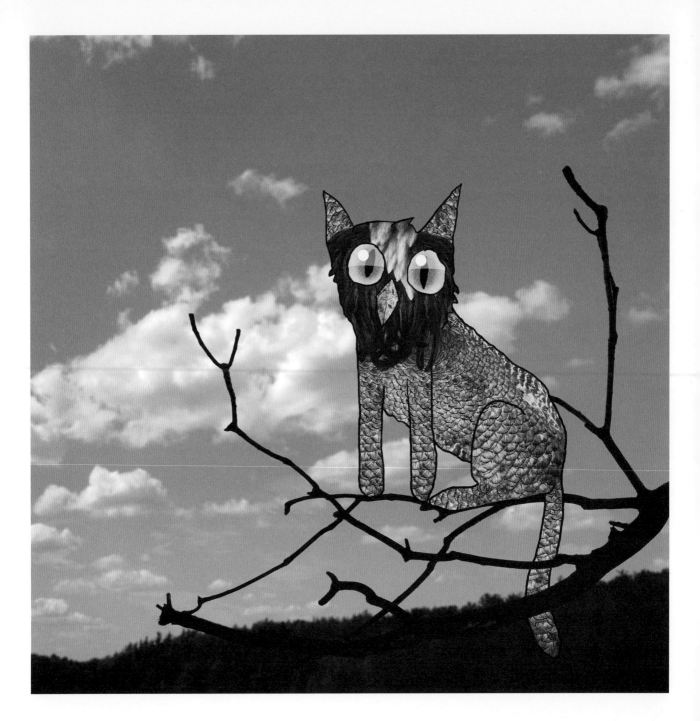

Catalyst

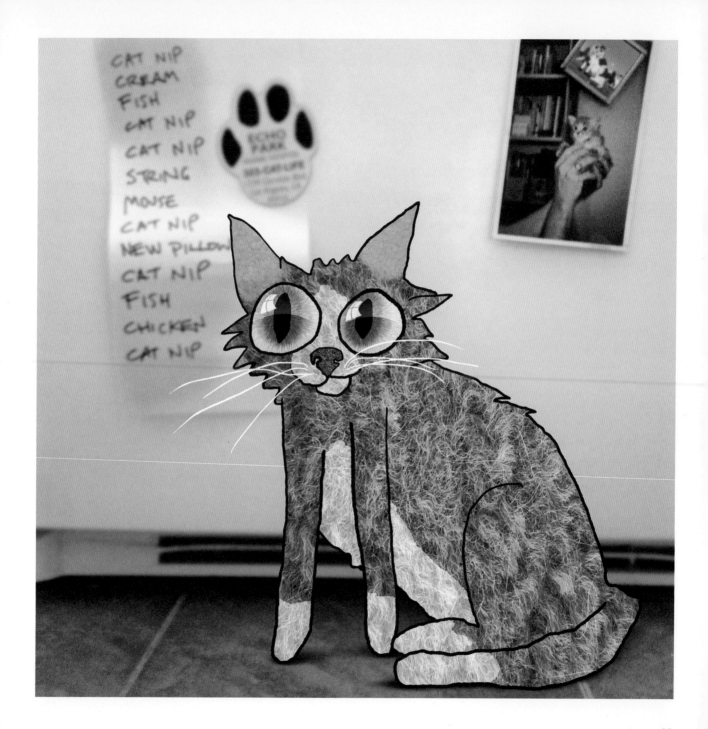

Cat's Cradle

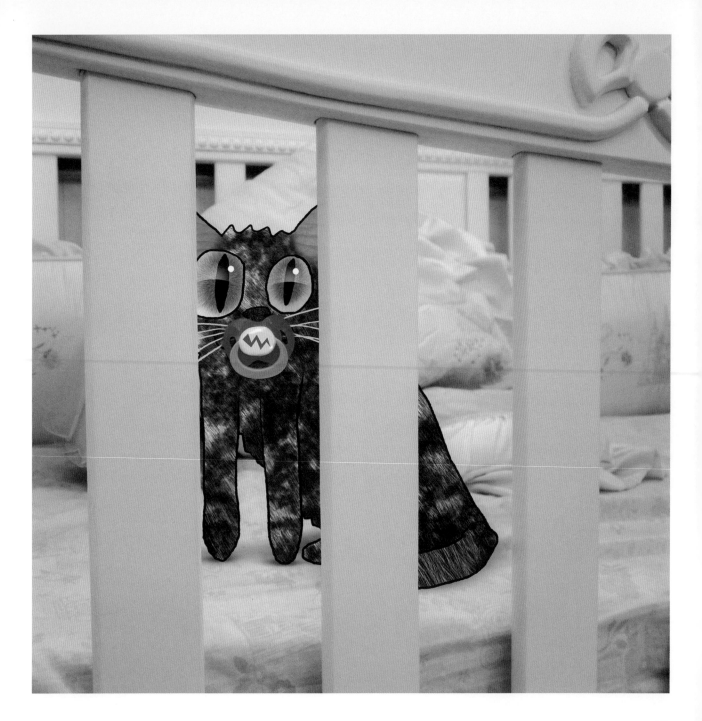

Tabby Cat

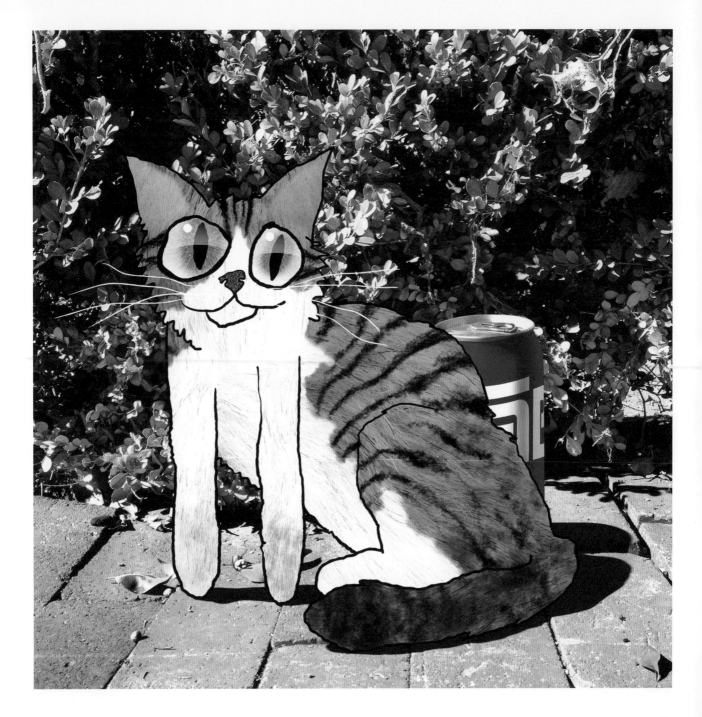

Stray Cat

Catwalk

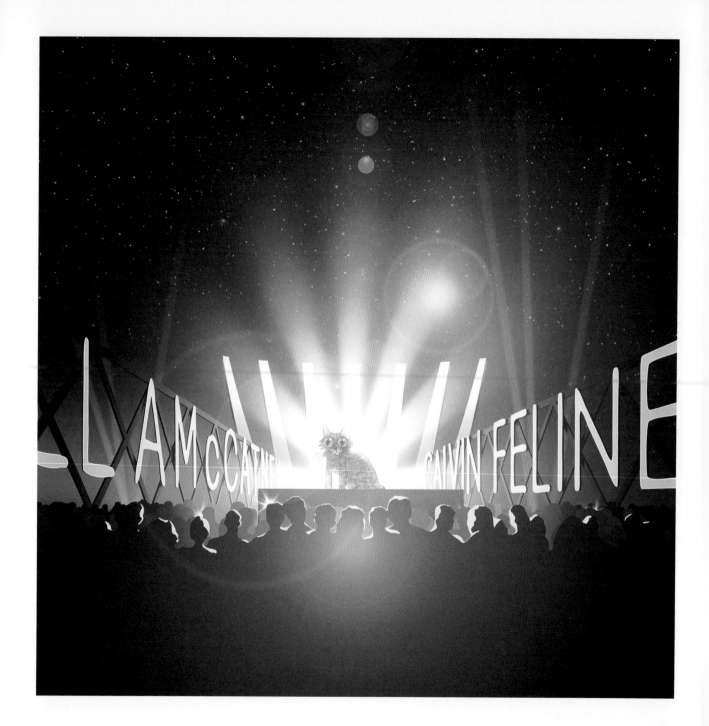

Cattle

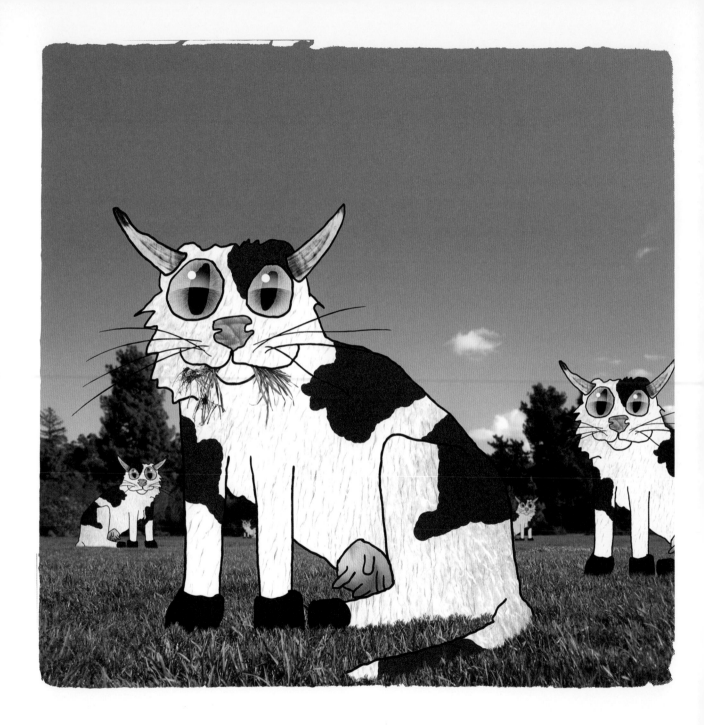

Catnip

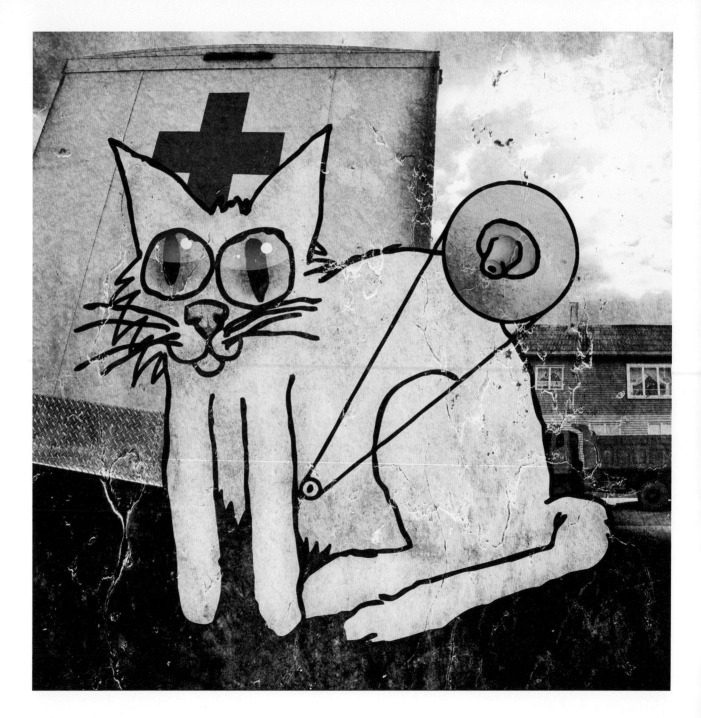

Catnap

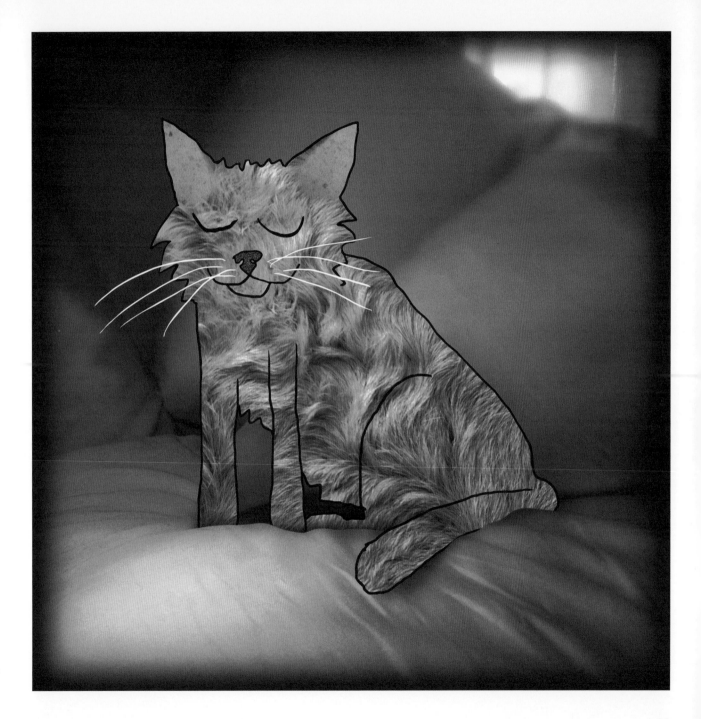

Catfight

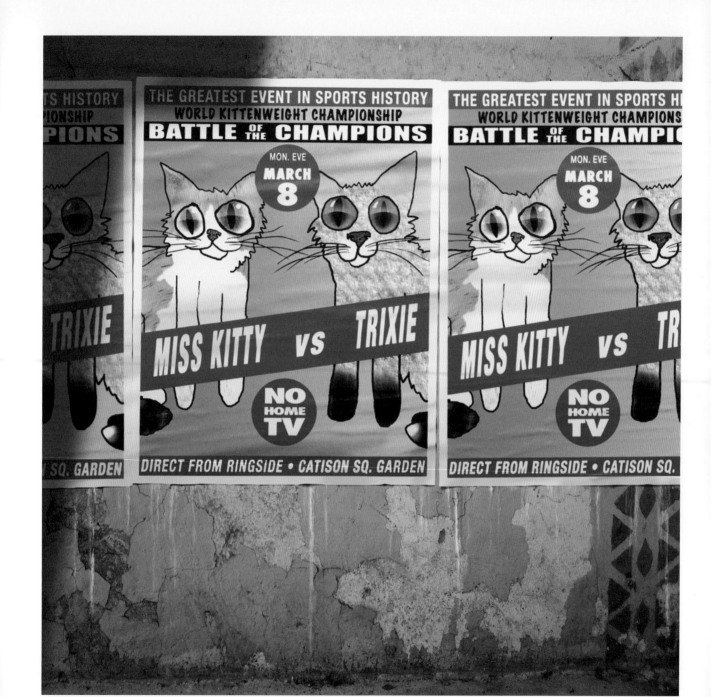

Caterpillar

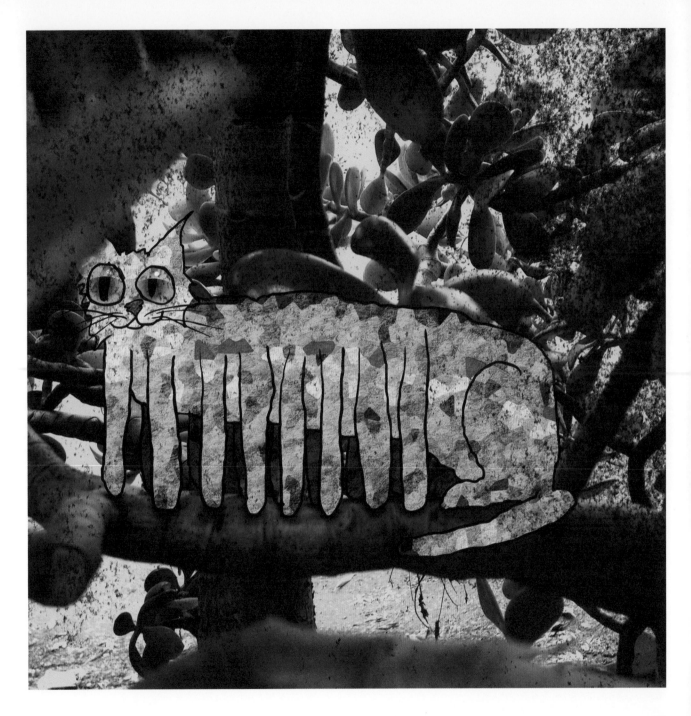

Catwoman

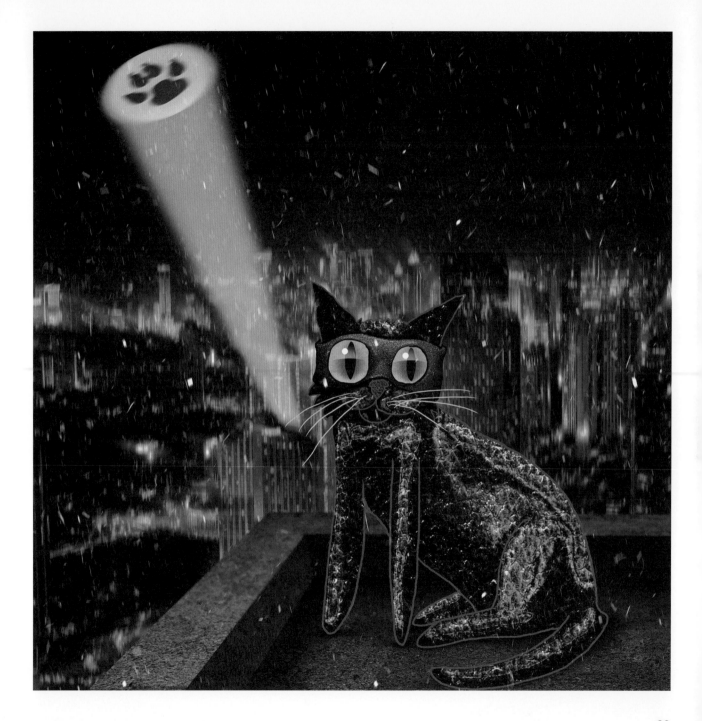

Sylvester the Cat

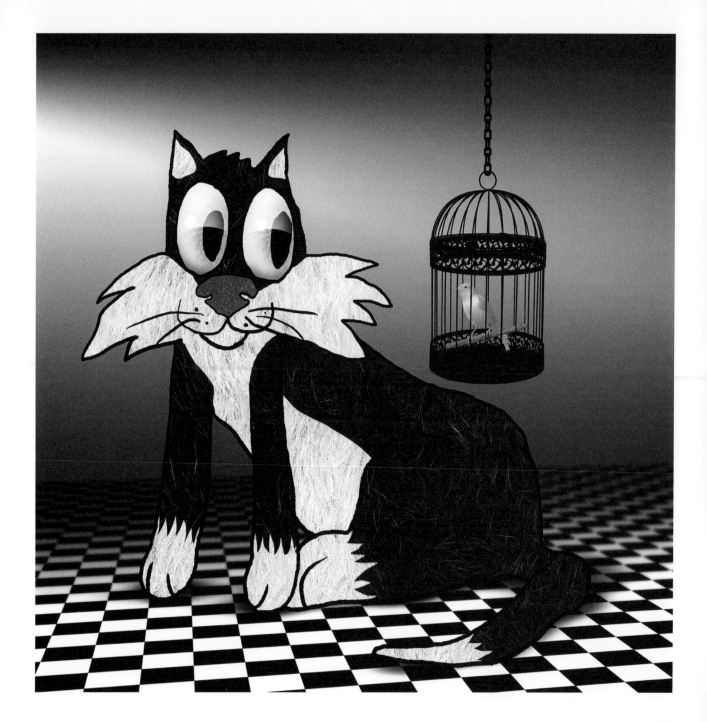

Tomcat

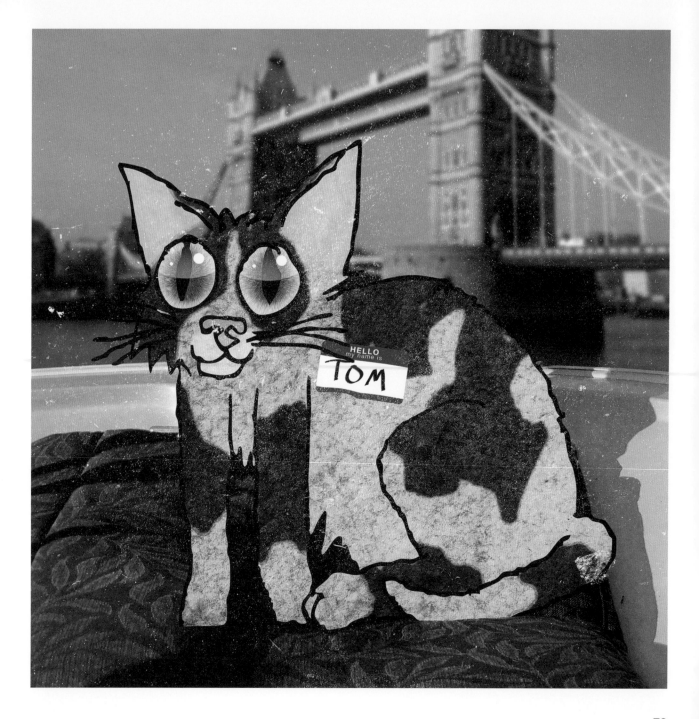

Cattywampus

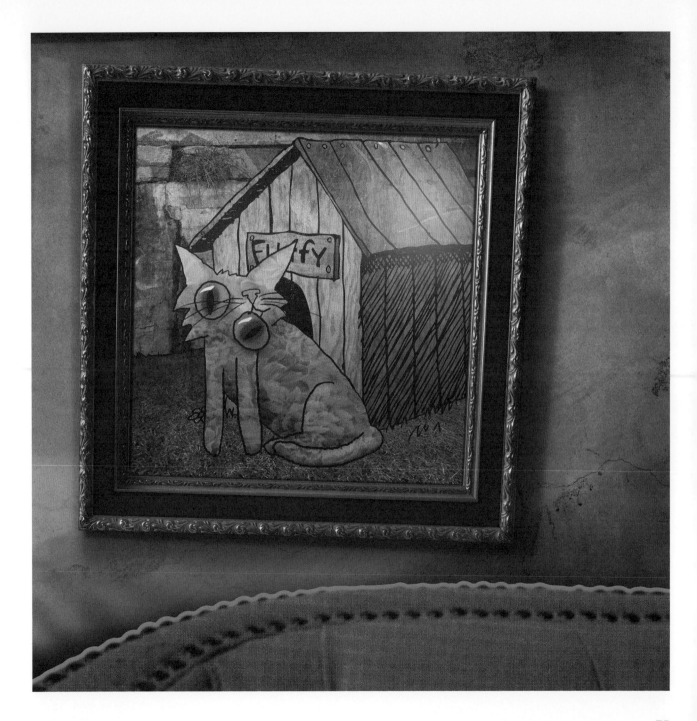

Catskills

Cat

Catlike

Fat Cat

Top Cat

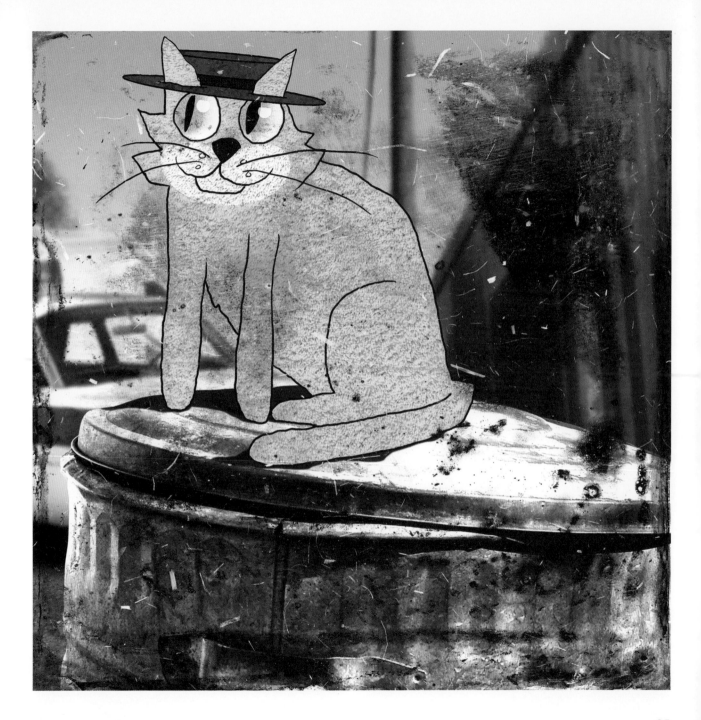

Cat and Mouse

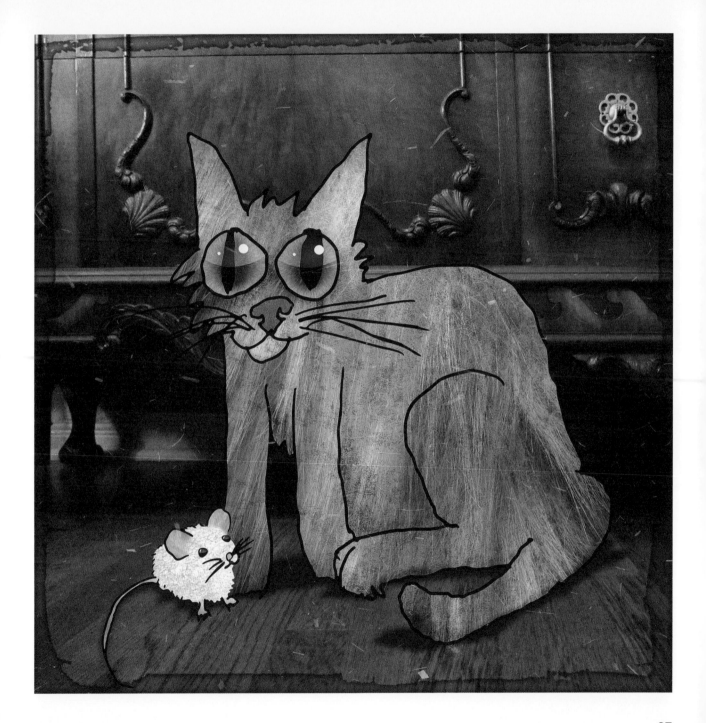

Cat's Pajamas

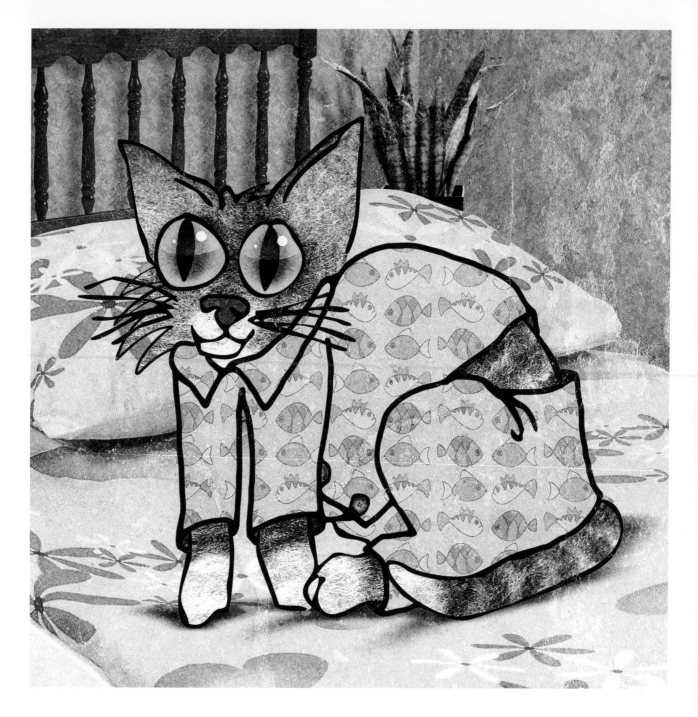

Stimpson J. Cat

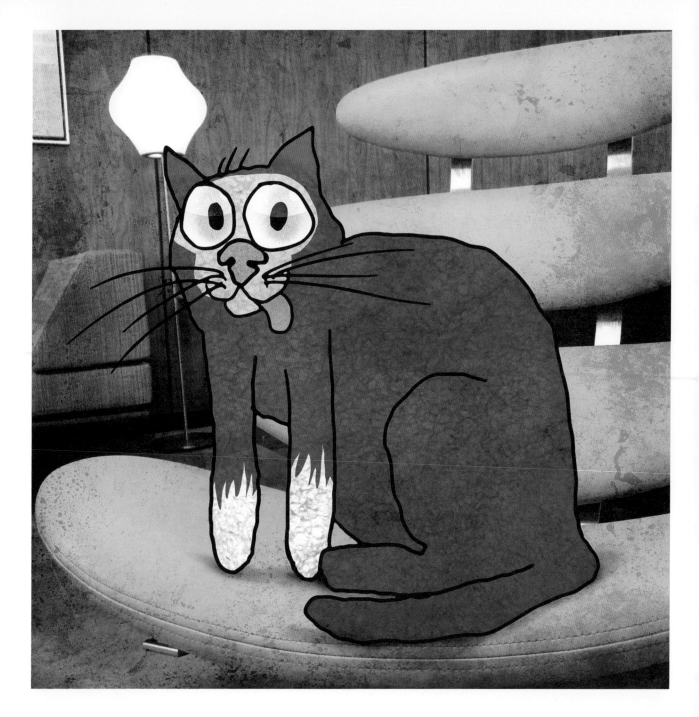

Black Cat

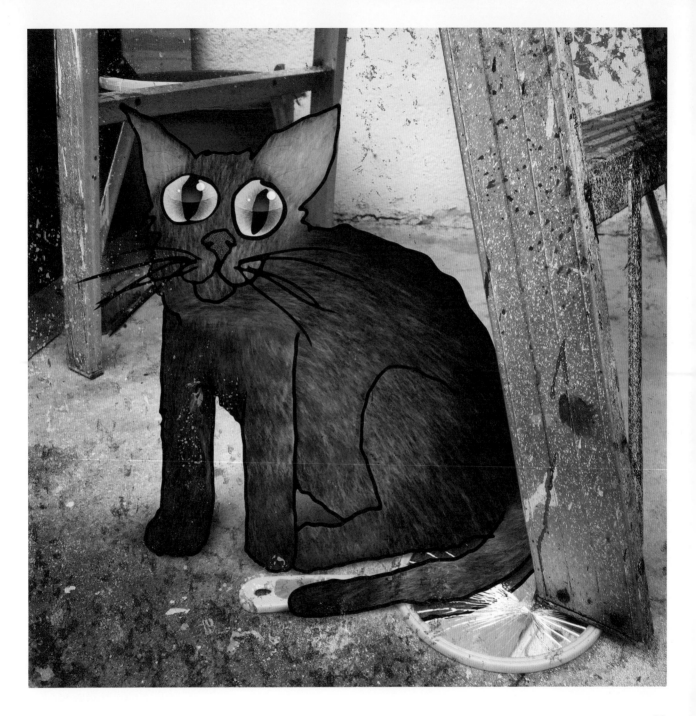

Scat

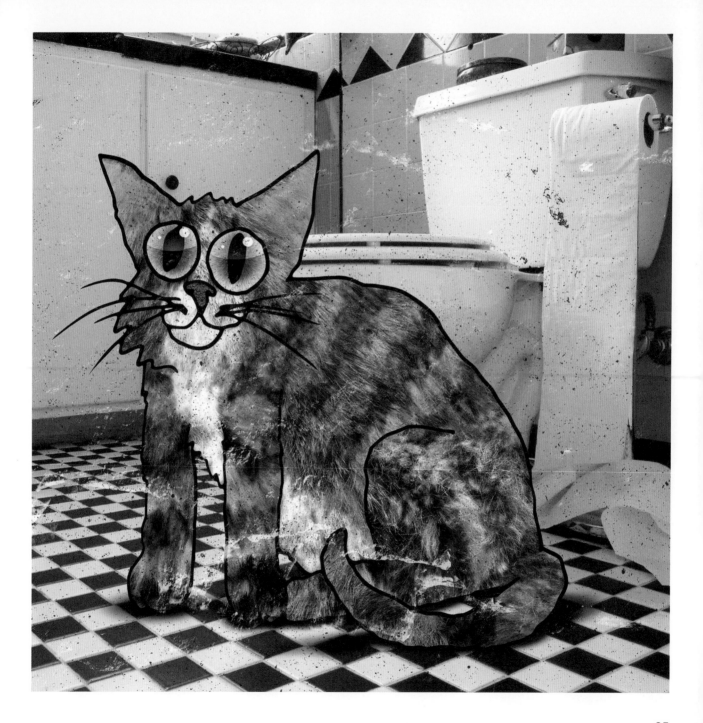

Category

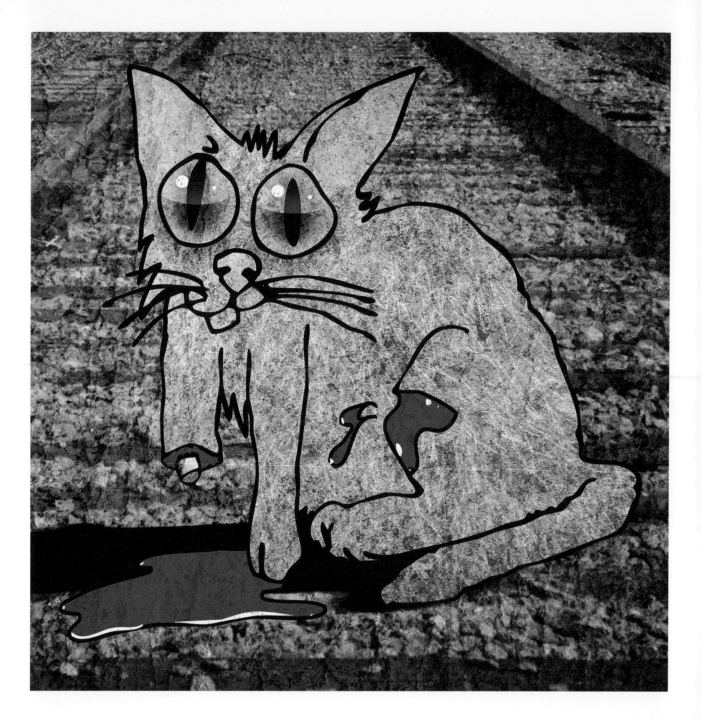

Catfish

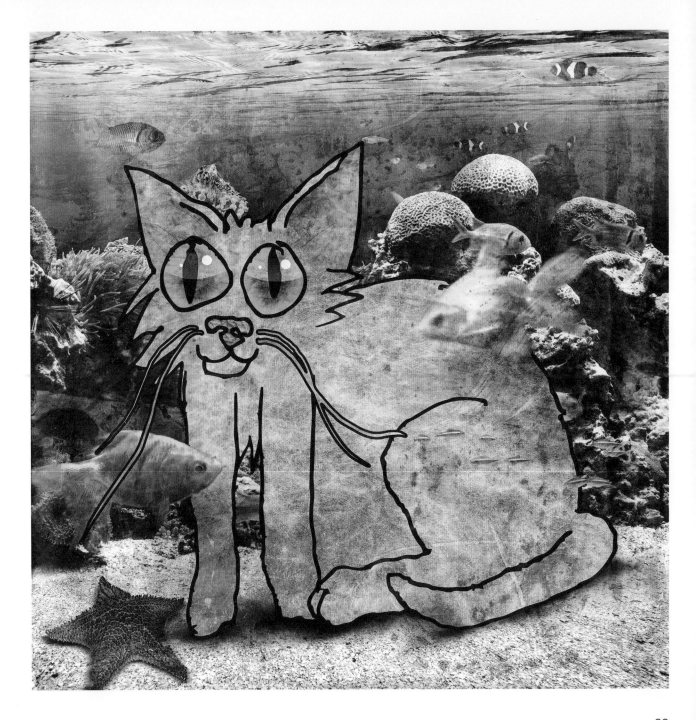

Cat Litter

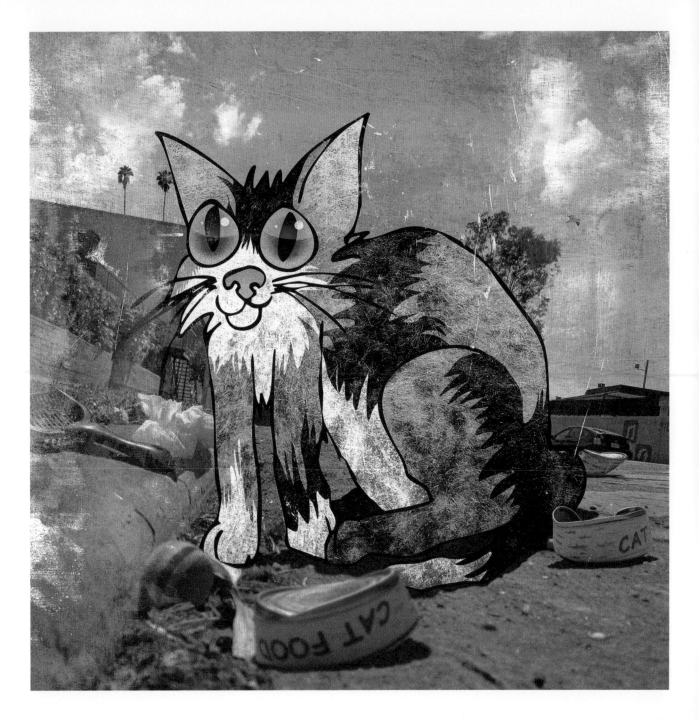

Cathouse

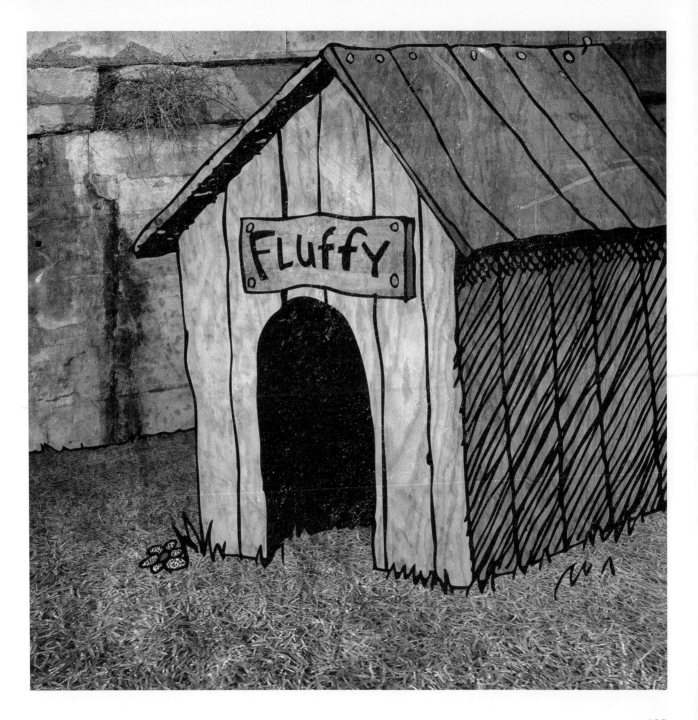

Catalog

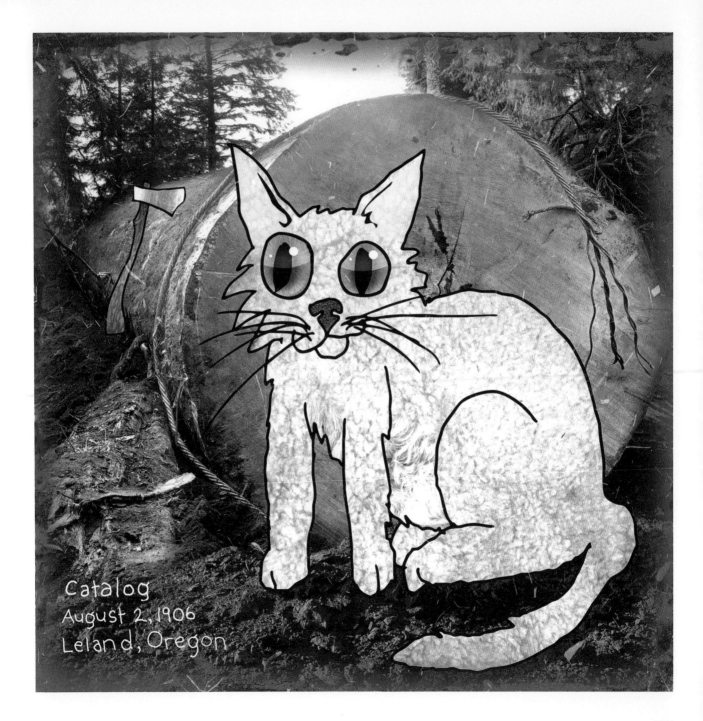

Catalog
August 2, 1906
Leland, Oregon

105

Big Cat

Cat Burglar

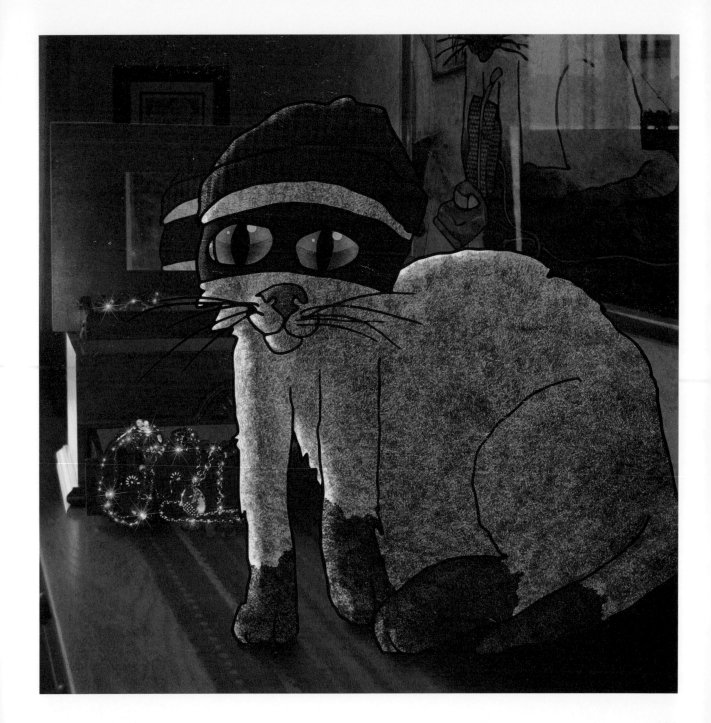

Copycat

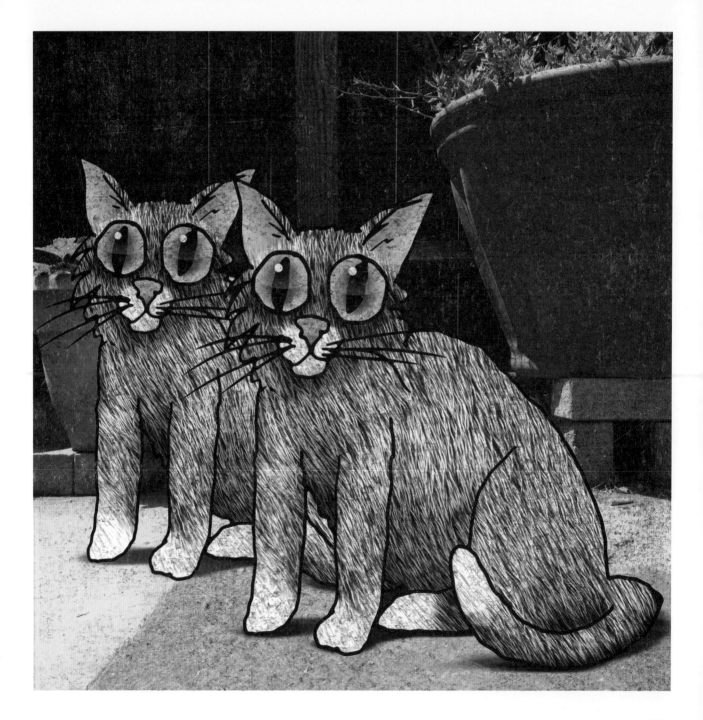

CAT Scan

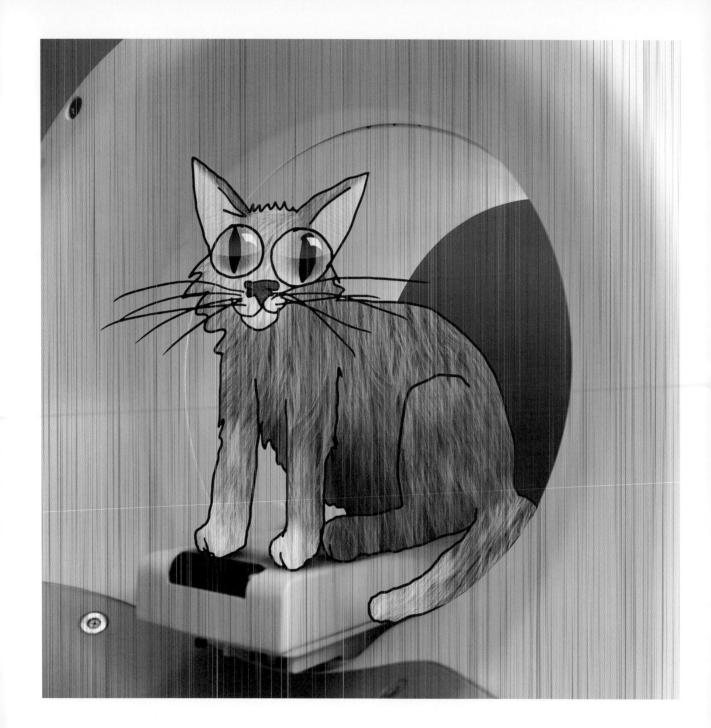

Catty-Corner

Catacomb

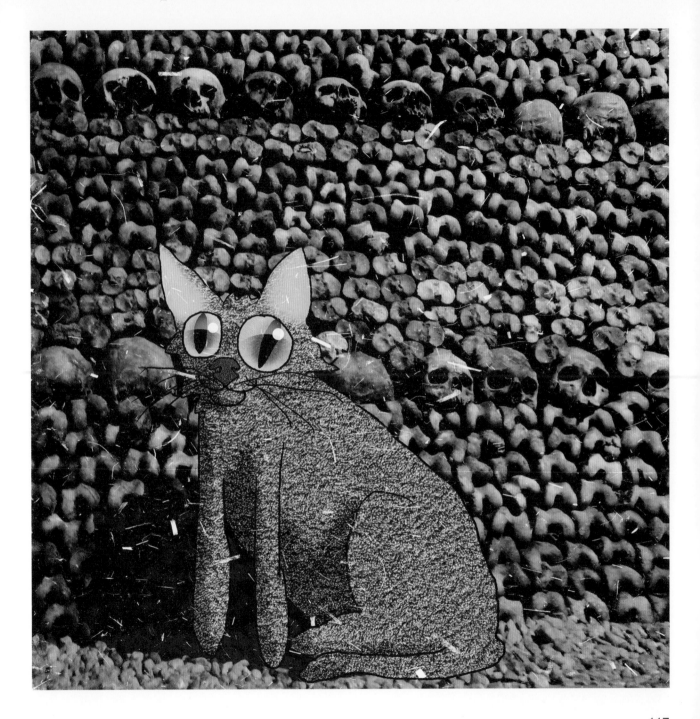

Cool Cat

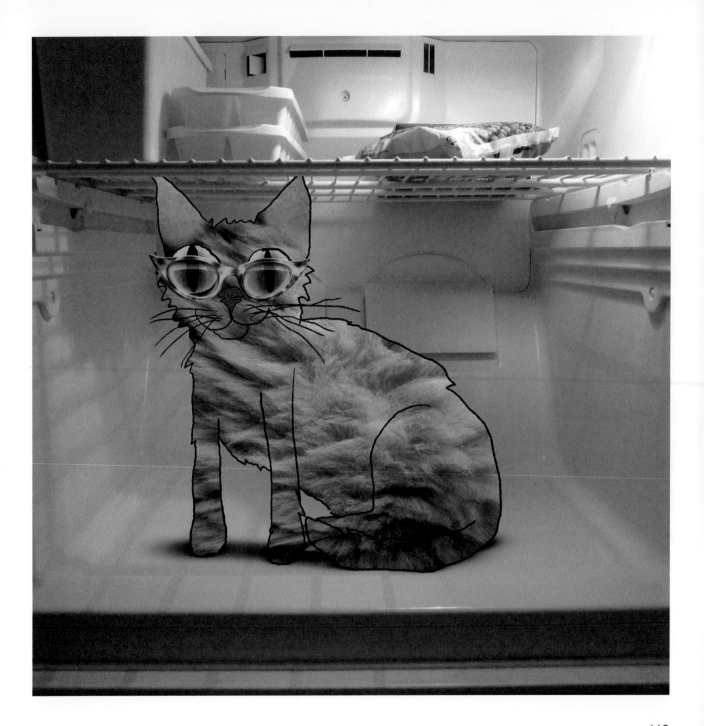

Cataract

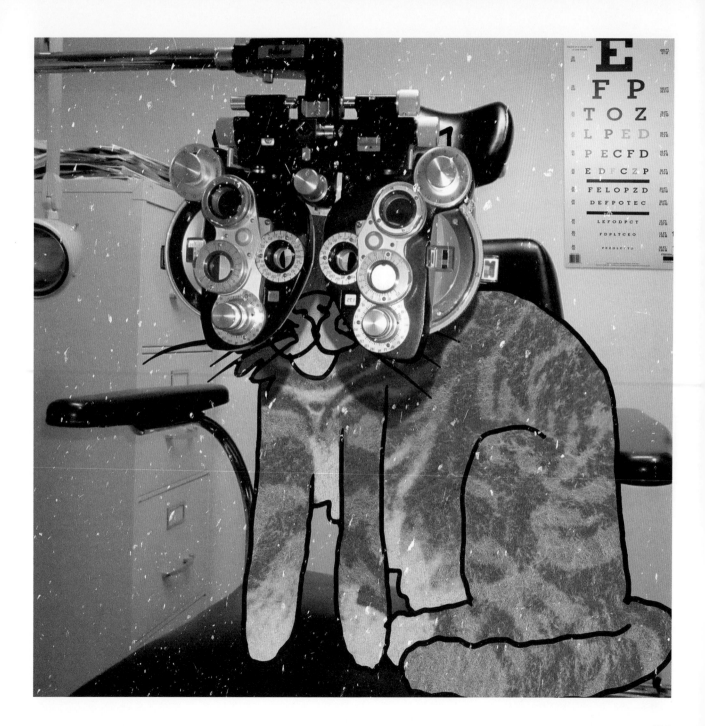

Scaredy-Cat

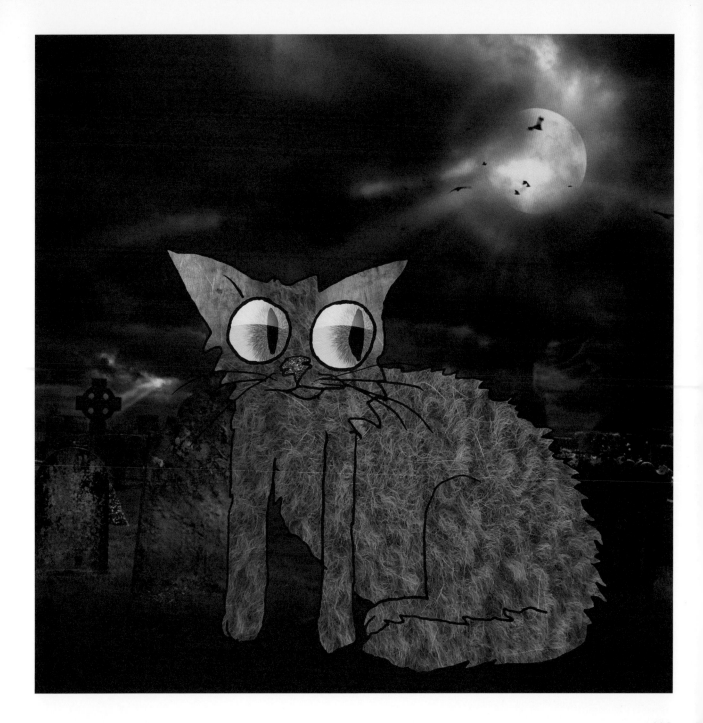

Wildcat

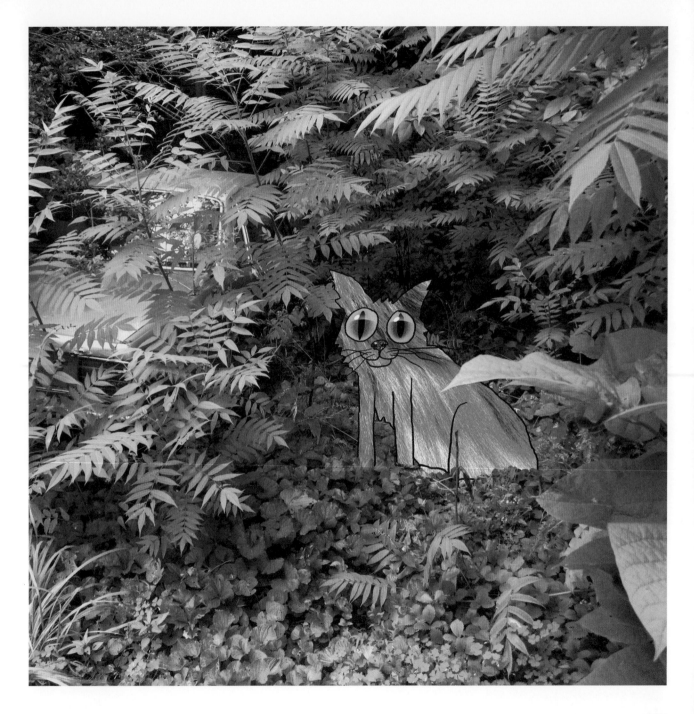

Cat-o'-Nine-Tails

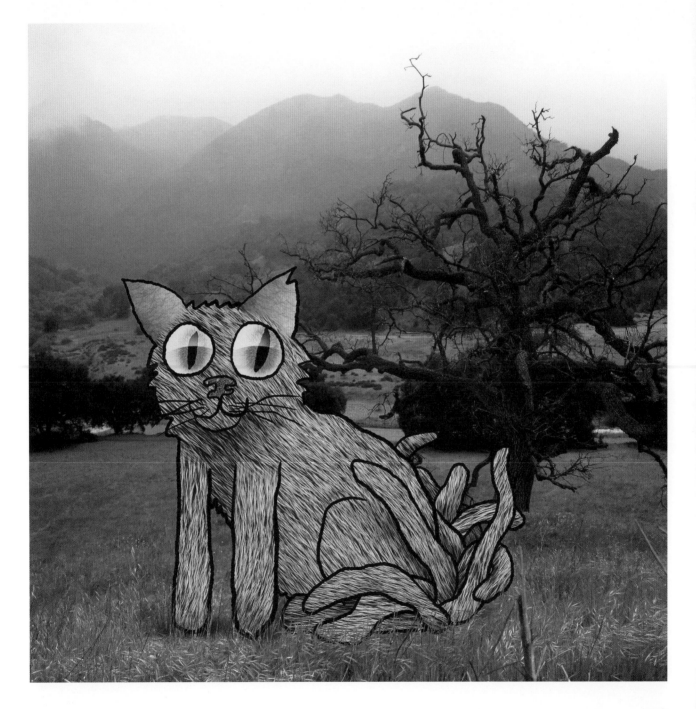

Cat Got Your Tongue?

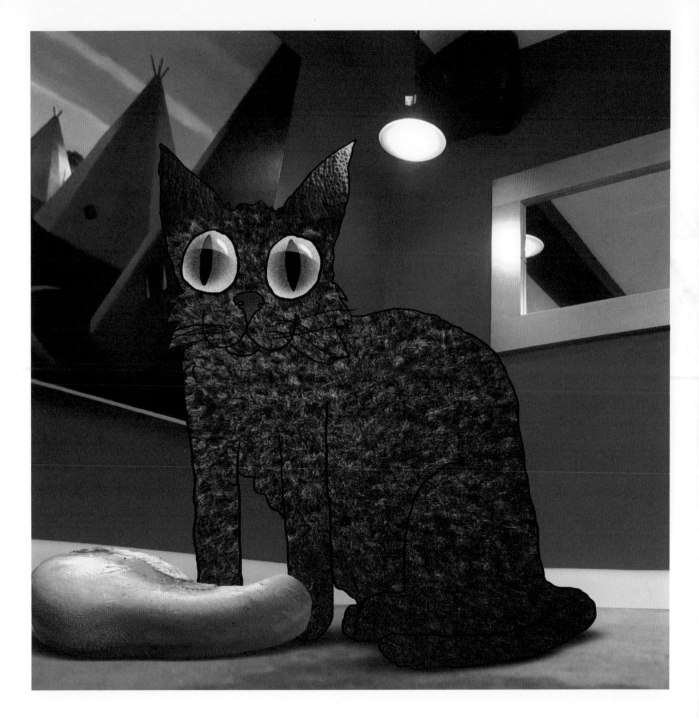

Catamaran

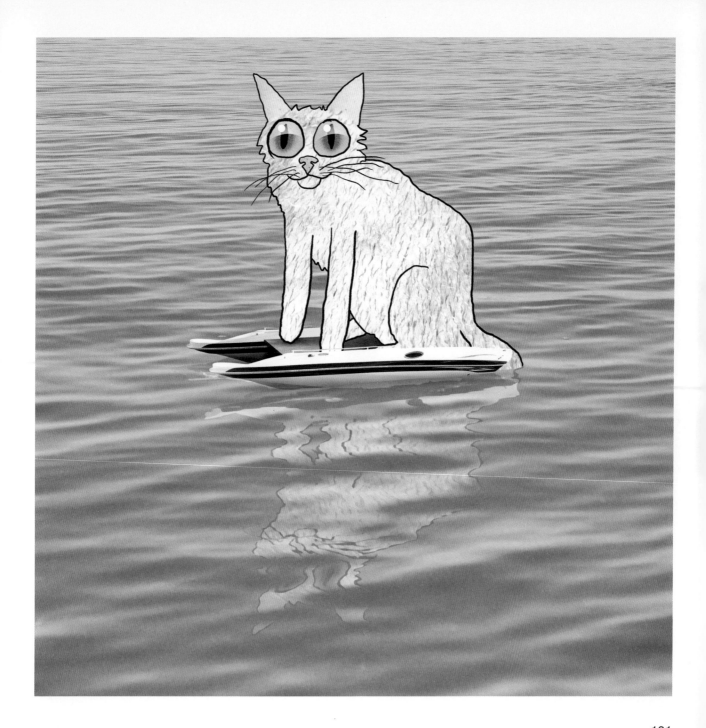

Cat Box

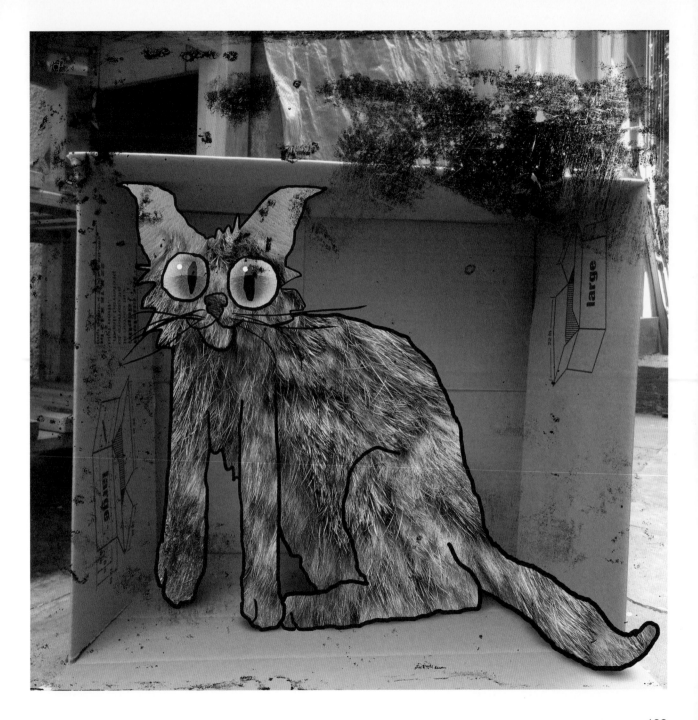

Cat's Meow

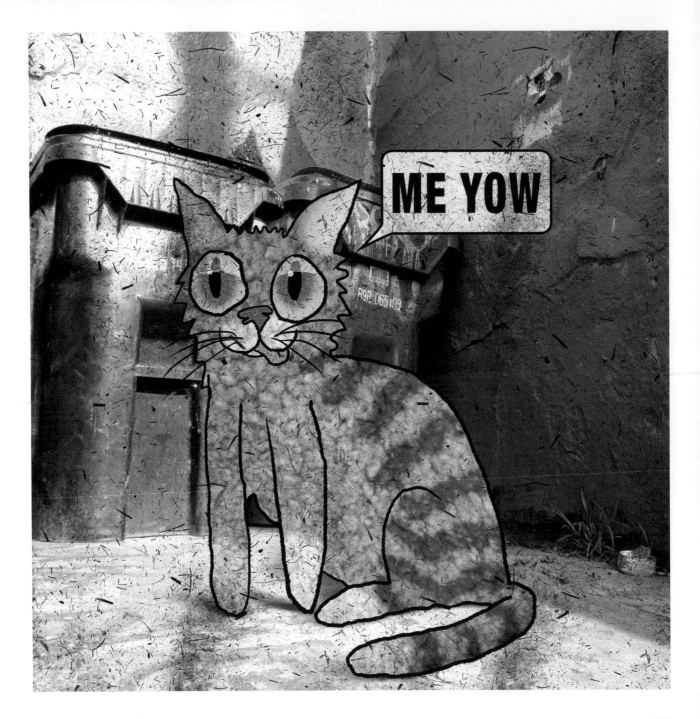

Cat in the Hat

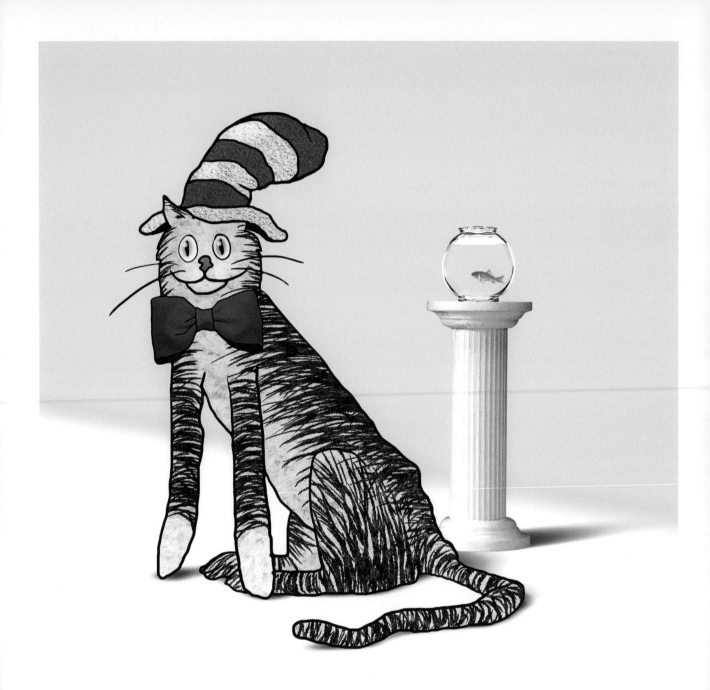

Cat Stevens

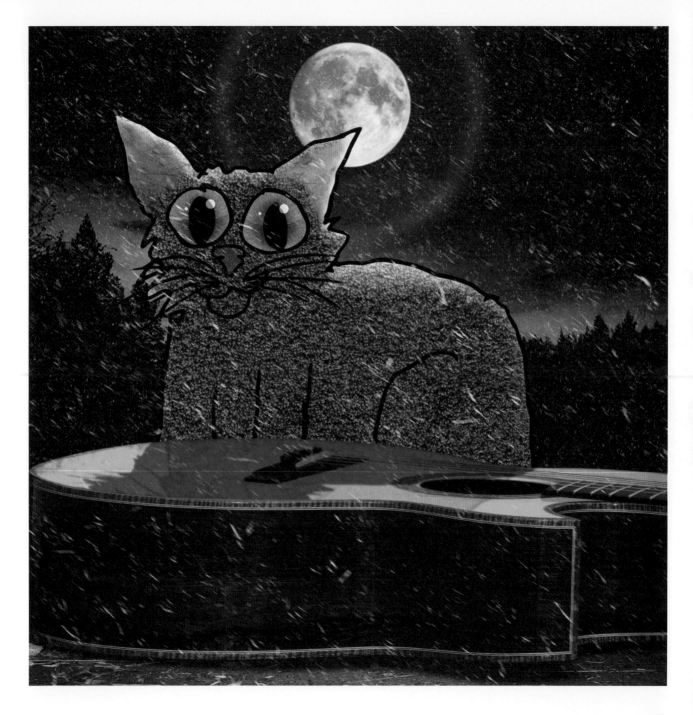

Catgut

Catapult

Catharsis

Cat Scratch Fever

Catsuit

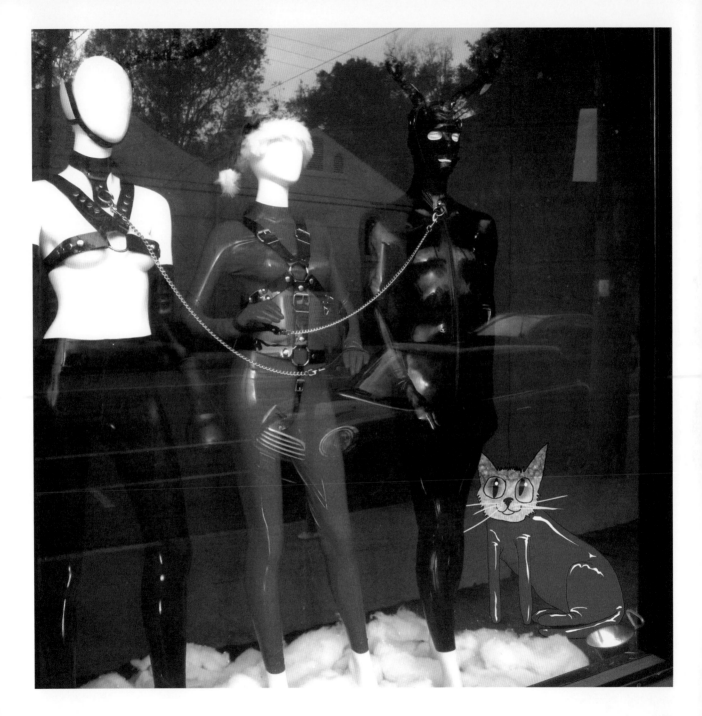

Cat Power

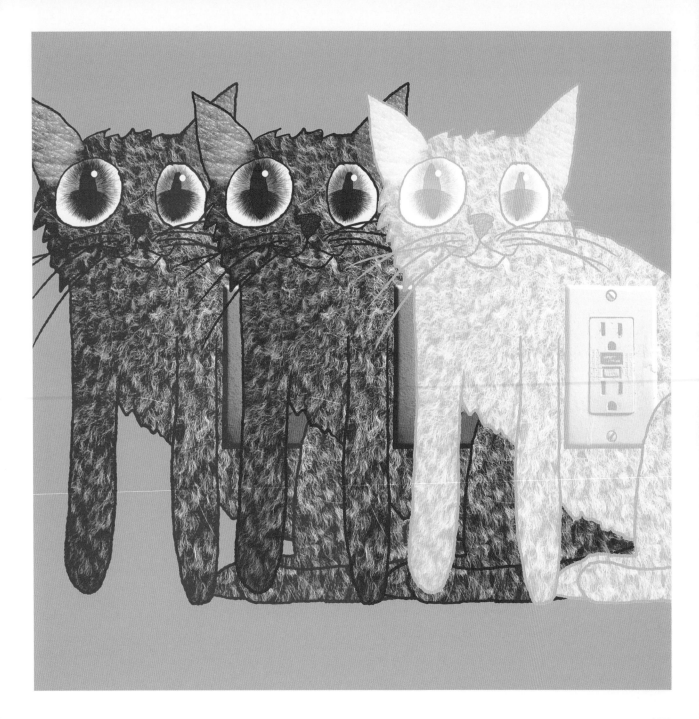

Cate Blanchett

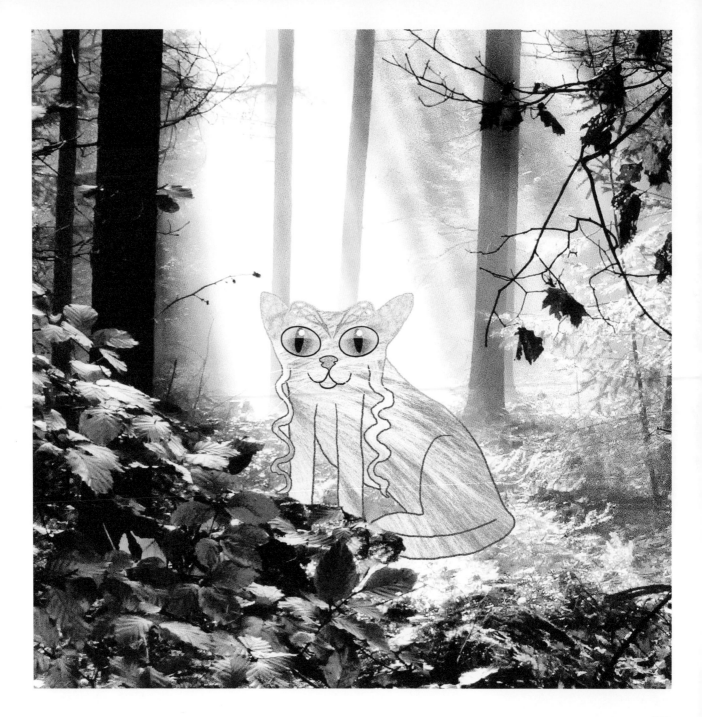

Catalytic Converter

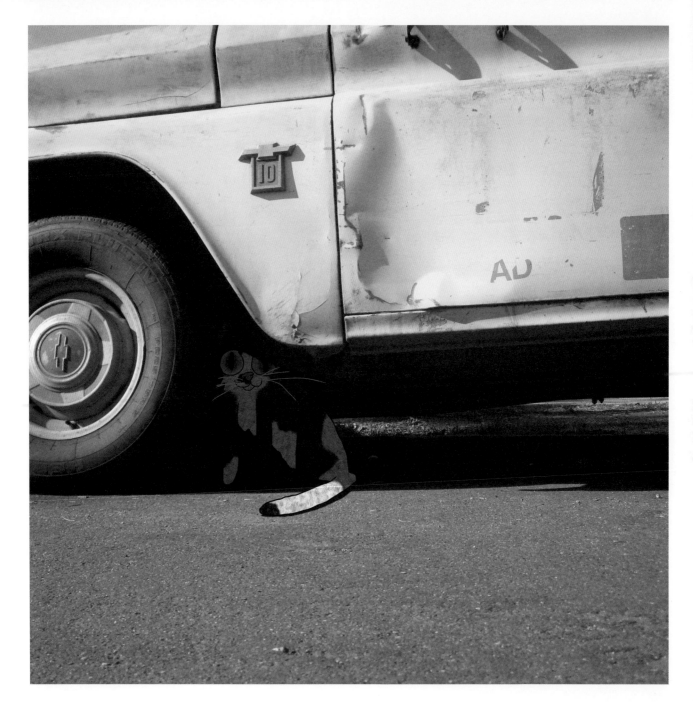

Caterer

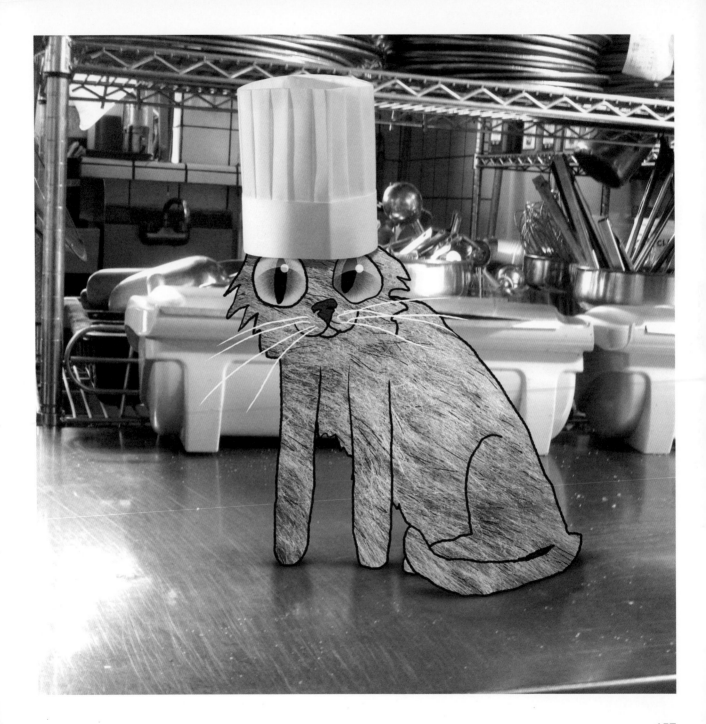

Index